50 WAYS TO
WEAR A SCARF

50 WAYS TO WEAR A SCARF

Lauren Friedman

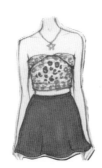
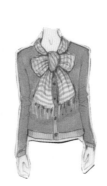

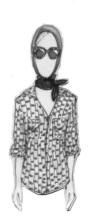

CHRONICLE BOOKS

SAN FRANCISCO

Library of Congress Cataloging-in-
Publication Data:
Friedman, Lauren, 1987–
 50 ways to wear a scarf / Lauren
Friedman.
 pages cm
 ISBN 978-1-4521-2597-8
1. Scarves. I. Title. II. Title: Fifty ways to
wear a scarf.
 GT2113.F75 2014
 391.4'1–dc23

 2013016520

Manufactured in China

MIX
Paper from
responsible sources
FSC® C008047

Designed by Allison Weiner
Design assistance by Sarah Higgins

10 9 8

Chronicle Books LLC
680 Second Street
San Francisco, California 94107
www.chroniclebooks.com

For my mom and grandma, who made me who I am today.

And to my all-time favorite scarf, pilfered from my mom's closet
and subsequently lost weeks later on New Year's Eve, 2011:
You would have looked great in this book.

CONTENTS

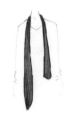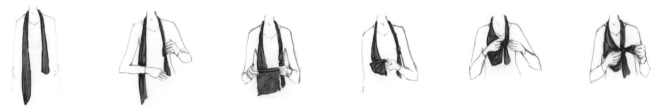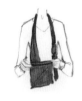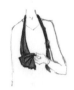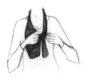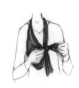

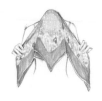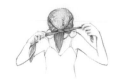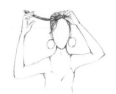

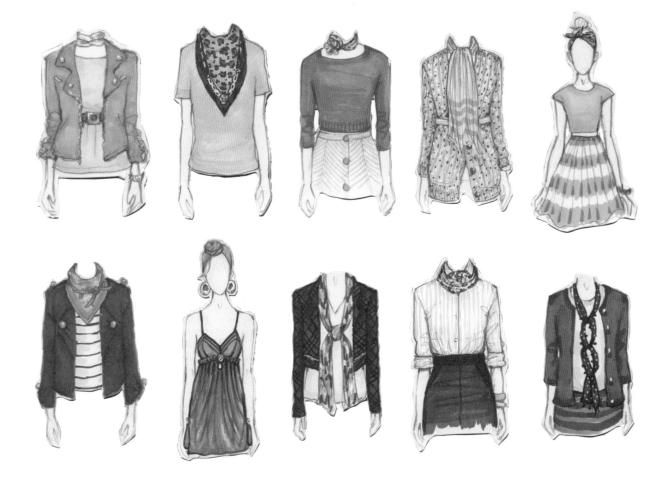

INTRODUCTION

A scarf is more than just an accessory; it has the power to transport your style to another time or place. If you're wearing classic pants with a simple top, pull out a favorite scarf, wrap it into one of the looks found in this book, and suddenly you're a French gamine on the banks of the Seine, a carefree coed skipping class in a convertible, or an anthropologist taking coffee with the local Bedouins. A scarf is the last flourish, the exclamation point to the daily narrative of getting dressed, and it has the ability to truly make an outfit.

My own scarf collection, which I've illustrated throughout this book, is more than just a pile of fabric. My scarves represent a series of stories and memories. The first scarf I ever remember wearing was a purple paisley hand-me-down from my mother's freewheeling single days. When I put it on, I was no longer just a little girl in middle school yearning to grow up. That scarf instantly transformed my daily uniform of a tee shirt and jeans into a look that said, "I'm a young woman with my own style and I march to the beat of my own purple paisley drum!"

I wrote this book to show you the many style possibilities held within a single scarf. If you're tired of doing a simple loop every time you reach for a scarf, fear not—I've illustrated fifty different techniques, and each one says something a little different. Pick and choose depending on your mood, the weather, or the occasion. Try the Audrey (page 98) for a day at the farmers' market, the Clutch (page 36) for a night painting the town red, or even the Pup (page 118) to accessorize a girl's best friend. Bring new life to the scarves in the back of your closet, and, above all, don't be afraid to be bold.

–Lauren

THE CLASSIC SCARVES

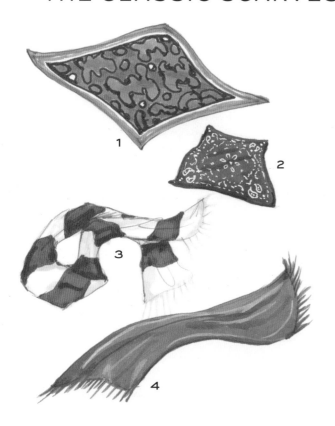

SQUARE SCARVES

1 pashmina or wrap made of cotton, silk, or cashmere

2 bandanna, handkerchief, or small silk square

OBLONG SCARVES

3 heavy knit for winter made of wool or cotton

4 a long swath made of silk, cotton, or cashmere

STORING YOUR SCARVES

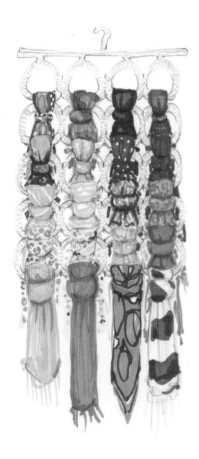

Keep your scarves in check! I like to use this type of organizer (available at IKEA) for my collection. Knot each scarf so that the loose ends are hidden and hanging down the back, then organize by type and color. It's a breeze to choose your latest look when all your scarves are visible.

THE LOOKS

★ THE BANDIT ★

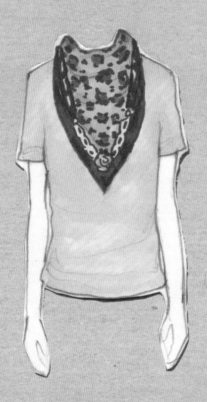

For the wily girl on the go, this desperado look
is a runaway success with any old rocker tee.

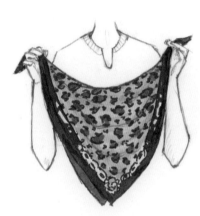

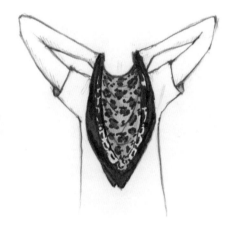

1 With a square scarf folded in half diagonally to form a triangle, gather the two folded corners.

2 Finish by knotting the folded corners together behind your neck.

ᐤ THE LOOP ᐤ

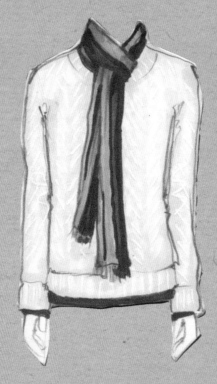

No muss, no fuss; pretty much any oblong scarf
will work for this simple style.

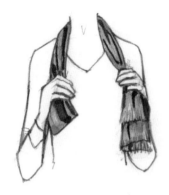

1 Drape a long scarf, folded in half widthwise, around the back of your neck.

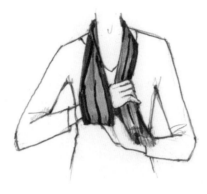

2 Reaching through the loop, grab the loose ends of the scarf.

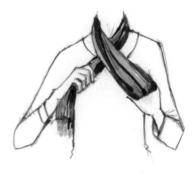

3 Pull the ends through the loop.

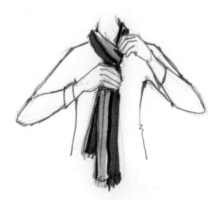

4 Tighten the scarf at the base of your neck to finish.

~ The Rosette ~

A beautiful bloom for any blushing lass, this twist will have everyone stopping to admire the rose at your collar.

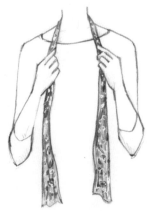

1 Drape a long, skinny scarf around the back of your neck so that both ends hang evenly down the front.

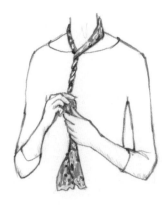

2 Starting near your neck, twist the ends together until you are a few inches away from the bottom.

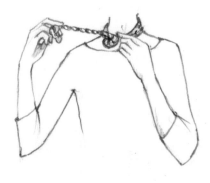

3 Wrap the twist up into a bun on the side of your neck.

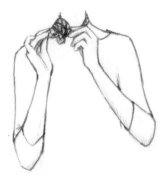

4 Tuck the ends underneath, and finish by gently splaying them out like the petals of a flower.

• THE PARIS •

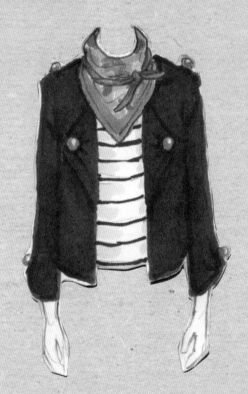

Just how do those Parisian *chéries* achieve that *je ne sais quoi*?
By mastering this elegant style, of course.

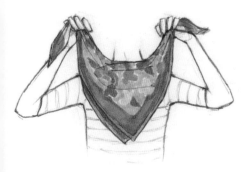 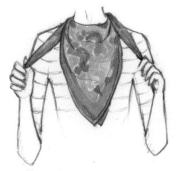 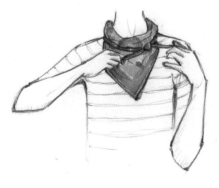

1 Fold a square scarf in half diagonally to create a triangle.

2 With the scarf in front of you, wrap the folded corners around your neck, crossing them once in the back.

3 Finish by knotting the folded corners together on top of the scarf in front.

THE MINNIE MOUSE

Our favorite lady mouse proves that there are few things
more charming than a big, floppy bow.

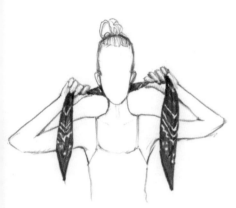

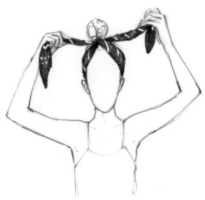

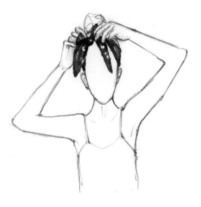

1 Place a long scarf at the back of your head at your hairline.

2 Bring the ends forward, tying once above your forehead.

3 Tie the ends into a bow.

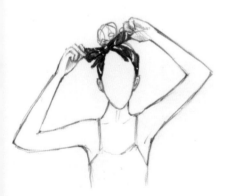

4 Finish by adjusting the bow as you see fit.

· The SQUARE ·

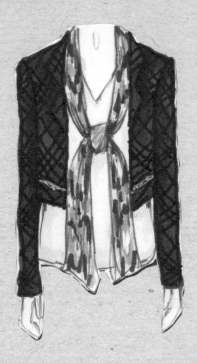

More cool than conservative, this simple style shows off
the color or pattern of your scarf.

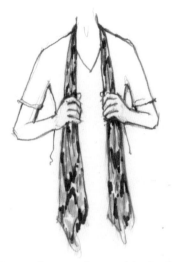 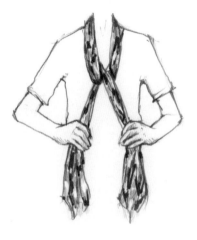 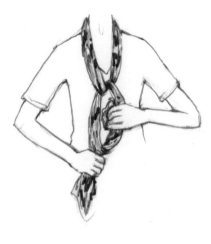

1 Drape a long scarf around the back of your neck so that the ends hang evenly in the front.

2 Tie the ends of the scarf together once at a comfortable distance below your throat.

3 Tie the ends together again in the same direction to finish.

⤙ THE ASCOT ⤚

Inspired by early-twentieth-century dandies,
this dapper style lets your scarf shine front and center.

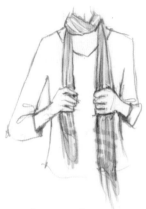

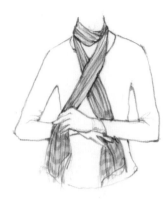

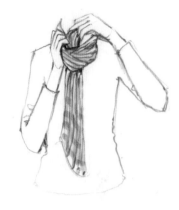

1 Wrap a long scarf once around your neck, letting one end hang slightly longer than the other.

2 Cross the long end over the short end.

3 Bring the long end under the short end and through the loop wrapped around your neck.

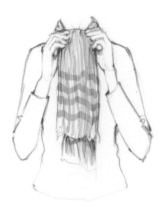

4 Finish by fluffing the top of the long end to give it volume and adjust the way it falls as you see fit.

THE DRAPE

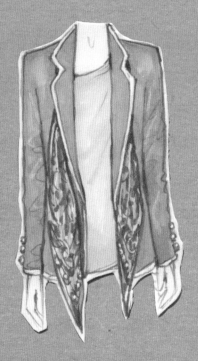

Choose your blazer and your scarf wisely when going for this style.
The sharp edges of the blazer's lapels will contrast nicely with a scarf that has lovely drape.

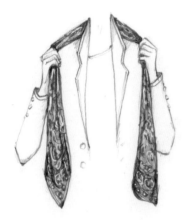 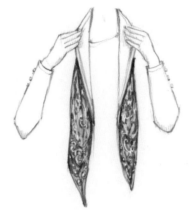

1 Pop the collar of your blazer and drape a long scarf around the back of your neck so the ends hang evenly in front.

2 Finish by folding the lapels of the blazer back down over the scarf, adjusting the scarf so it hangs how you desire.

··· The Professor ···

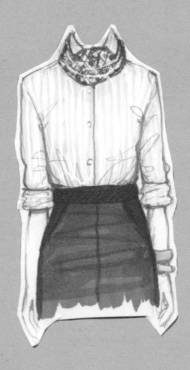

Give this collar-hugging style an A+.
Wear it with a crisp button-down shirt, and you'll
definitely be on the tenure track.

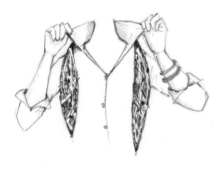

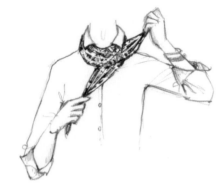

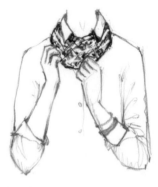

1 Fold a small square scarf in half diagonally to form a triangle. Then, fold over the long edge, in one-inch sections, to form a rectangle. Pop the collar of your button-down and drape the folded scarf around the back of your neck.

2 Wrap the scarf around your neck.

3 Tuck in the ends so the scarf is secure.

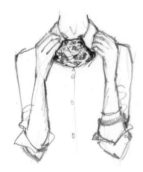

4 Fold your collar back down so it rests over the scarf to finish.

❧ THE CLUTCH ☙

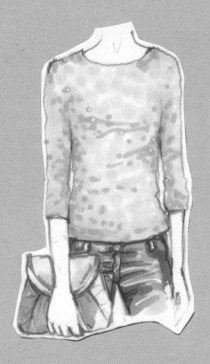

You're an original—so why shouldn't your clutch be?
For an ingenious remix, wrap a coordinating scarf around your favorite handheld purse.

1 Choose a clutch and square scarf that coordinate well. (How about a suede purse with a silk floral? Or a snakeskin clutch with an animal print?)

2 Fold the scarf diagonally to form a triangle, and bring the long folded edge around the back of your purse, aligned with the purse's top edge, with the loose corners of the scarf pointing downward.

3 Open the flap of the purse, bring one folded corner of the scarf across the front, and tuck it into the purse opening.

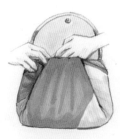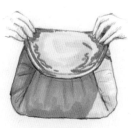

4 Bring the other folded corner of the scarf across the front of the purse, tucking it into the purse opening.

5 Grab the loose bottom corners of the scarf and fold them up, envelope-style, over the other folds and tuck them into the purse opening.

6 Finally, close the flap back over the body of the wrapped purse.

❃ THE NECKLACE ❃

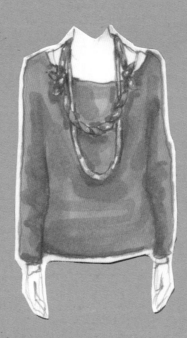

Take inspiration from the statement necklaces in your wardrobe.
This scarf style is as delicate and eye-catching as your most treasured bijoux.

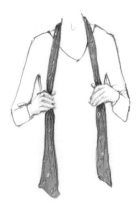

1 Drape a long, skinny scarf around the back of your neck so the ends hang evenly in front.

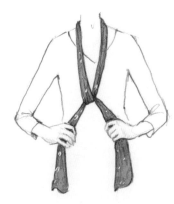

2 Tie the ends together once, low, creating a loop the length you'd like your "necklace" to be.

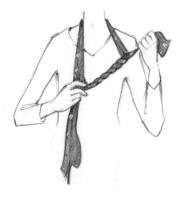

3 Wrap one loose end of the scarf around the loop you've created, back up toward your neck, forming a twist.

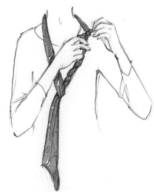

4 When the entire end has been twisted, knot the loose end to the loop near your neck.

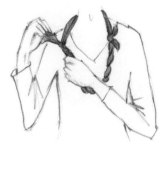

5 Finish by repeating on the opposite side.

∞ The Chain Link ∞

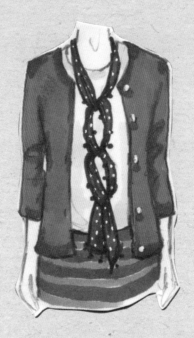

Like a stack of bracelets in an "arm party," the more links
the merrier in this show-stealing look!

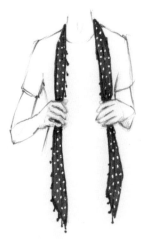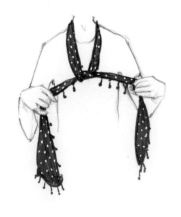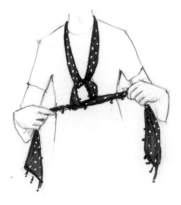

1 Drape a long, skinny scarf around the back of your neck so that the ends hang evenly in front.

2 Tie the ends together once, leaving some space between the tie and your neck.

3 Leaving space between the original tie, repeat ties once or twice in the same direction to create the look of a chain link down your front until you are close to the ends. Finish with one final tie.

⟿ The Easy Breezy ⟾

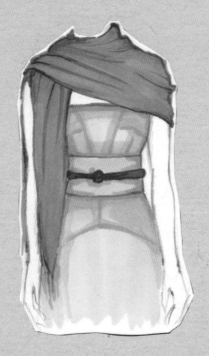

When combined with a strapless cocktail dress,
this effortless look will blow everyone away.

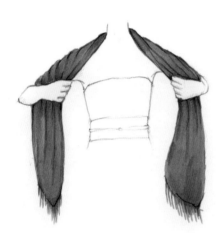
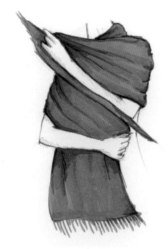

1 Drape a large scarf, wrap, or pashmina around the back of your neck, spreading the scarf over your shoulders.

2 Toss one end over the opposite shoulder to finish.

- THE TOP DOWN -

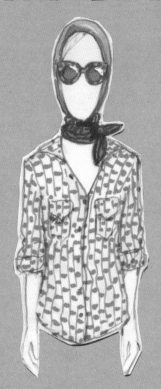

Reign as queen of the road with this classic head cover.
Cat-eye sunglasses and a convertible are a must.

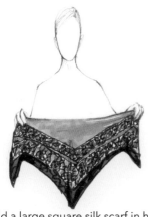

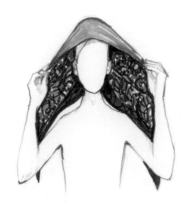

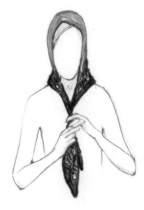

1 Fold a large square silk scarf in half diagonally to form a triangle.

2 Bring the scarf over your head, with the long folded edge at your forehead and the loose corners pointing down the back of your neck.

3 Cross the folded corners in front beneath your chin.

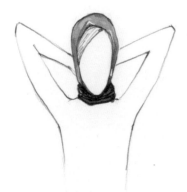

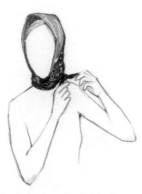

4 Bring the folded corners back around your neck.

5 Finish by knotting the folded corners together at your neck, tucking the loose corners under the knot.

»→ THE BOY SCOUT ←«

Earn your merit badge with this wholesome neckerchief.
Worn with crisp neutrals, it pledges adventure—scout's honor!

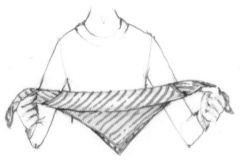 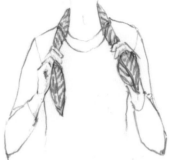 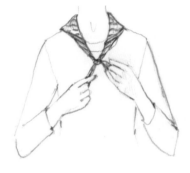

1 Fold a small square cotton bandanna in half diagonally to form a triangle. Then, in one-inch sections, fold over the long edge of the bandanna twice.

2 Drape the bandanna around the back of your neck so that the ends are even in front and the loose corners are hanging down your back.

3 Knot the folded corners together in the front at the base of your throat to finish.

⚡ THE NEW YORK ⚡

Master winters Big Apple-style with this warm yet trendy look.

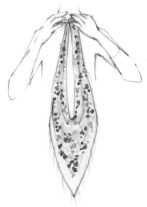

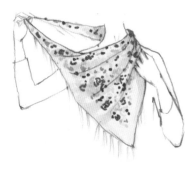

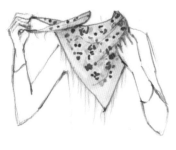

1 With a large square scarf folded in half diagonally to form a triangle, knot the two folded corners together.

2 Bring the loop over your head, leaving the knotted section slack.

3 Twist the slack to create a second loop.

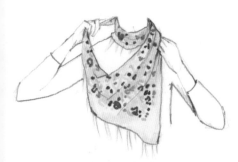

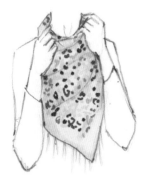

4 Bring the second loop over your head again.

5 Hiding the knot under the loose corners, finish by fluffing the scarf to create volume and adjust as you like.

• THE XX •

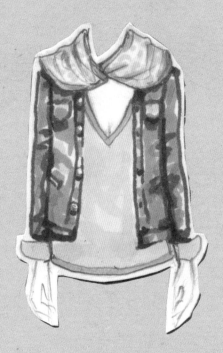

Crisscross this uncomplicated tie over your head
and around your neck for a fluttery collar effect.

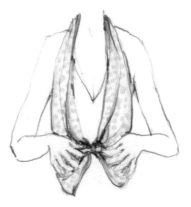

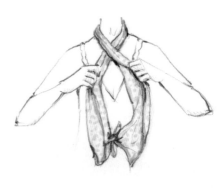

1 Drape an oblong scarf around the back of your neck so the ends hang evenly in front.

2 Knot together the two inside corners.

3 Twist the scarf once to make an X.

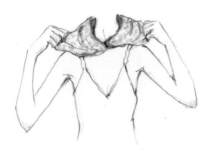

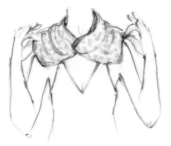

4 Flip the scarf over your head, putting your head through the bottom loop created by the X.

5 Finally, adjust as you see fit.

18

⤞ THE PONYTAIL ⤝

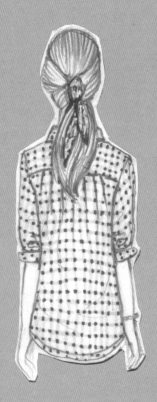

Weave a scrap of silk into your ponytail for a major hair upgrade.
This look works best with second-day hair or hair styled with dry shampoo or texturing spray.

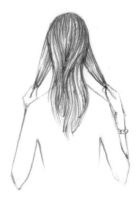

1 Separate your hair into three sections.

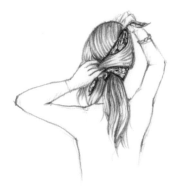

2 With a small oblong or square scarf folded into one long length, wrap the scarf around the middle section of your hair, then wrap the right end of the fabric with the right section of hair as if you were starting a braid.

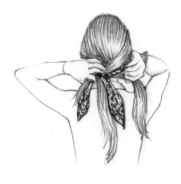

3 Continue braiding your hair while incorporating the scarf.

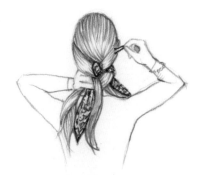

4 As you go, place hairpins to hold the scarf and your hair in place.

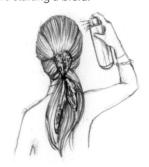

5 Finish with hairspray.

❧ THE BRAID ❧

If you can braid your hair, you can braid your scarf.
Try this sophisticated move with one of your favorite long scarves.

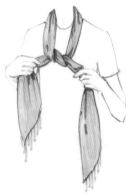

1 Drape a long rectangular scarf around the back of your neck and tie the ends together once at your chest, at the length you'd like your braided "necklace" to be.

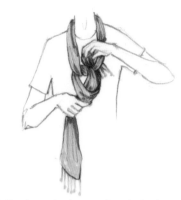

2 Begin to tie the scarf again in the same direction, bringing the end through the backside of the loop hanging around your neck so that you are "braiding" around the scarf.

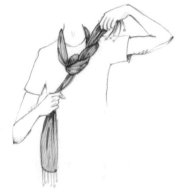

3 As you bring the end through, pull up so the knots begin to flatten in a braid pattern.

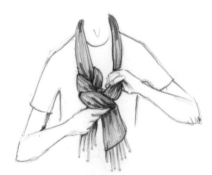

4 Tie again, bringing the end back up and around the loop around your neck.

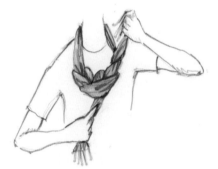

5 Continue in the same manner, pulling the end up to create a braid, moving until you reach the end of the scarf.

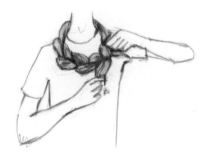

6 Secure the ends with one final tie.

THE **POCKET SQUARE**

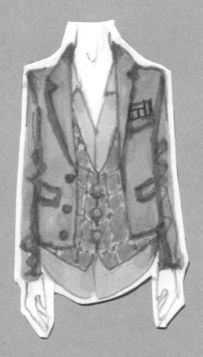

Go a little more traditional and tuck a dapper pocket square
into your blazer pocket. There are many different ways to fold
a pocket square; this method is the quickest and easiest.

1 Fold a freshly ironed handkerchief or small square scarf in half to create a rectangle.

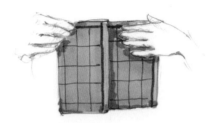

2 Fold the rectangle into thirds.

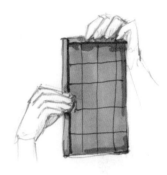

3 Crease the edges as you go to help the scarf maintain its shape.

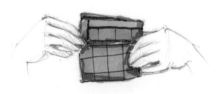

4 Fold the bottom half up so it almost meets the top edge.

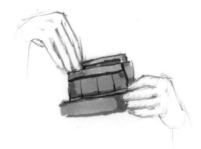

5 Turn the pocket square around and place it in your jacket pocket with the loose edges pointing upward.

6 Finally, adjust so only a sliver of the pocket square is visible.

- THE TIE -

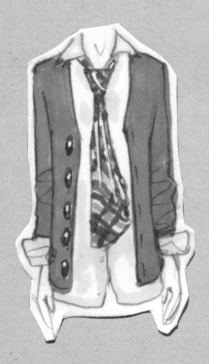

Once you're practiced in this borrowed-from-the-boys classic,
expect the man in your life to come asking for help tying his own.
Employ a traditional tie, or go feminine with a long scarf.

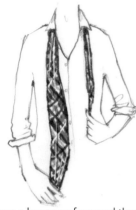

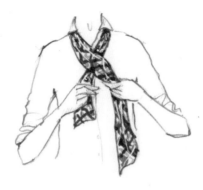

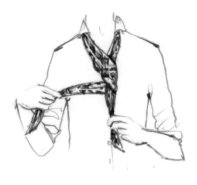

1 Drape a long scarf around the back of your neck, letting one end hang longer than the other.

2 Bring the long end over the short end.

3 Wrap the long end under the short end.

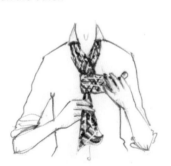

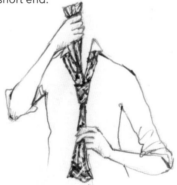

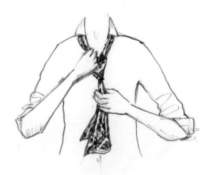

4 Bring the long end forward once more, wrapping over the short end.

5 Pull the long end behind the short end and then up through the loop around your neck.

6 Tuck the long end through the front of the knot you created and adjust the length, tightening all the way up to your throat for a more formal look, or leaving it lower for a relaxed vibe.

❧ The Cinnamon Bun ❧

Inspired by the classic breakfast treat, this scarf style has all the swirly fun of a cinnamon bun without the calories. To make sure the look stays sweet all day, secure the scarf with bobby pins.

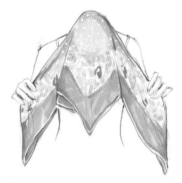

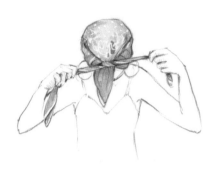

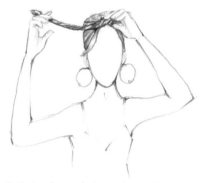

1 With a large square scarf folded in half diagonally to form a triangle, drape the scarf over your head, with the long folded edge at the back of your head at the hairline and the loose corners draped over your forehead.

2 Bring the folded corners on either side forward and tie once at the top of your head, over the loose corners at your forehead.

3 Twist the ends into a rope, incorporating the loose scarf corners.

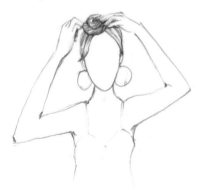

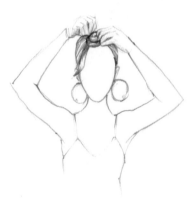

4 Wrap the twist into a bun.

5 Finish by tucking in the ends securely.

❧ THE KIMONO ❧

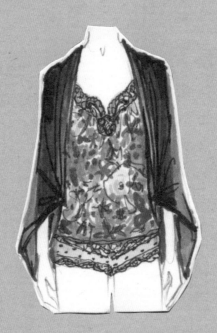

Pay homage to the elegance of a traditional Japanese kimono
with this look. It works well with your best lingerie and kitten heels
for an evening in or on top of a formfitting dress for a night out.

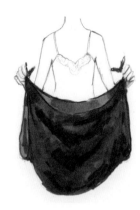

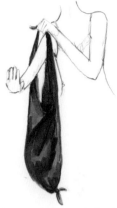

1 Fold a large scarf with lovely drape in half widthwise.

2 On the opposite side of the fold, knot the matching loose corners together, creating two knots.

3 Insert one arm through the long open end of the scarf and out through one of the short open ends. Bring the scarf behind you and repeat with the other arm, so that one knot comes over your right shoulder and one knot comes over your left.

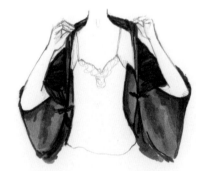

4 Finally, adjust the scarf so that the knots fall below your arms, allowing the scarf to fall over your shoulders.

✳ The Chain Weave ✳

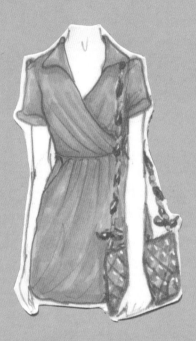

It was Coco Chanel who first put a chain handle on her iconic quilted bag.
Stand on the shoulders of giants and weave a scarf through your own purse's handle
for a touch of feminine sophistication.

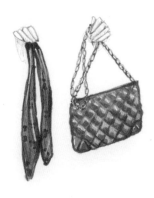

1 Choose a long scarf that complements your chain-handled purse.

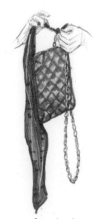

2 Knot the scarf to the base of the chain.

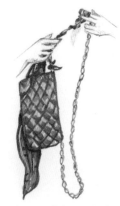

3 Weave the scarf through the chain.

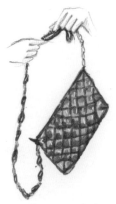

4 Continue until you reach the end of the scarf.

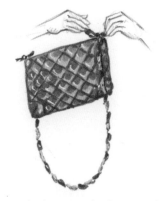

5 Secure by knotting the loose end of the scarf to the opposite base of the handle. (If the scarf is shorter than the chain, just tie it to the chain when you reach the end of the scarf.)

�҂ THE BAND AND TWIST ✸

This adorable head wrap is an easy way to get your hair off your face on a hot day or during a killer workout.

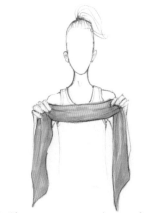

1 Choose a rectangular scarf.

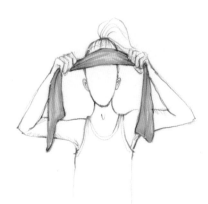

2 Place the scarf at the low center of your forehead.

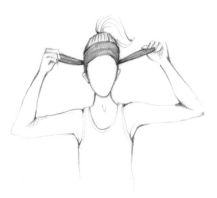

3 Cross the ends in the back.

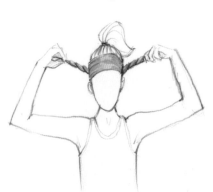

4 Twist the ends into two coils.

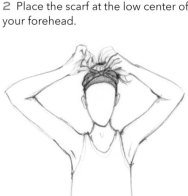

5 To finish, bring the coils forward to the forehead and knot securely. You may tuck the ends under the coil, or leave them untucked.

The Hourglass

Behold, the fastest way to add definition to your figure.
Choose a belt at least one inch wide for this straightforward style.

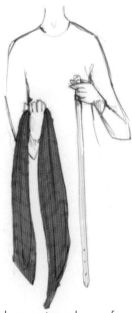

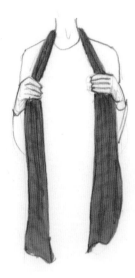

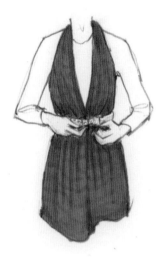

1 Pick a long rectangular scarf and a belt that go well together.

2 Drape the scarf around the back of your neck so the ends hang evenly in front.

3 With the ends of the scarf lying flat down your front, buckle the belt on top of the scarf. Ensure that you place it at the smallest part of your waist, just below your rib cage.

< THE PREP >

Any true blue-blood will feel comfortable in this scarf version of the preppy sweater-over-the-shoulder look. Sporting this classic style conjures dreams of summering on Martha's Vineyard and drinking gin and tonics.

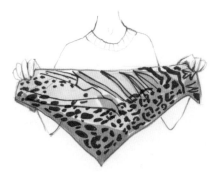 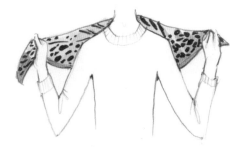 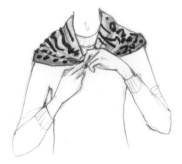

1 Fold a large square scarf in half diagonally to form a triangle.

2 Bring the long folded edge of the scarf around the back of your shoulders with the loose corners pointing down your back.

3 Knot the folded corners together at the base of your neck to finish.

»THE LAZY GIRL«

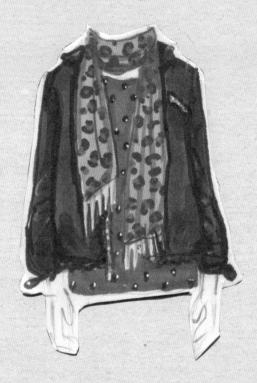

Even lazy girls can look pulled together in a pinch.
Employ this simple style as a time-saving measure to get out the door!

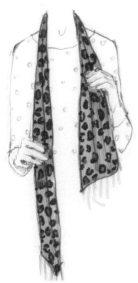

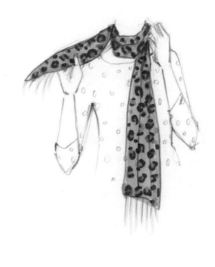

1 Drape a long scarf around the back of your neck, letting one end hang longer than the other down the front.

2 Wrap the long end once around your neck, bringing it forward and finishing with both ends hanging down your front.

The Frida

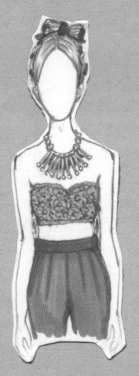

Ms. Kahlo understood the power of a good scarf look.
Entwining a scarf with your braided hair simultaneously conveys
artistry, strength, and beauty. (Extra points for a strong brow!)

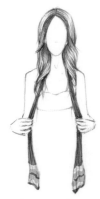

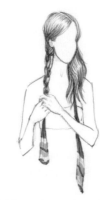

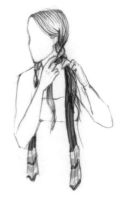

1 Drape a long scarf around the back of your neck underneath hair that has been separated into two sections.

2 Divide each section of hair in three, and incorporate the scarf into one section of hair as you braid to the ends. (If you have "slippery" hair, secure the braid's end with a hair tie.)

3 Repeat on the other side.

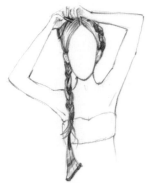

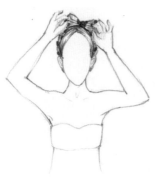

4 Bring the braids up around the crown of your head, pinning in place.

5 Finally, tie the ends of the scarf together; fluff the ends to give the impression of a flower. (Or add some flowers of your own!)

❀ the knot ❀

Elegant with both solid and patterned scarves, this deceptively simple style
is a trouble-free way to add texture to casual and dressy outfits alike.

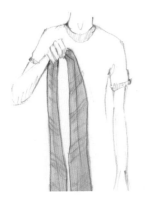

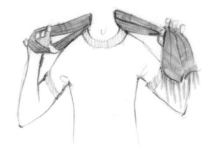

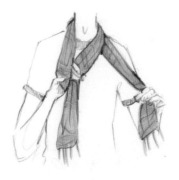

1 Fold a long rectangular scarf in half widthwise.

2 Bring the scarf around the back of your neck so that the folded side is in one hand and the two ends are in your other hand.

3 Through the fold, grab one end of the scarf.

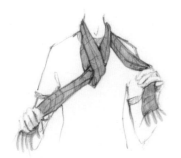

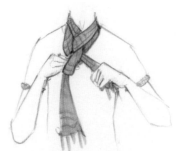

4 Bring that end through the fold.

5 Bring the remaining loose end over the top of the folded side of the scarf and then pull through the fold. This end will come out of the fold on the opposite side to create the "knot" effect.

⊶ THE BUSTIER ⊷

Worn with a high-waisted skirt on a hot day or underneath a jacket for a unique evening look, your favorite large scarf can moonlight as a top in this sexiest of styles. For those girls with gals bigger than an A cup, a strapless bra is recommended.

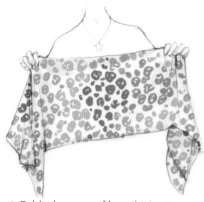

1 Fold a large scarf lengthwise to your desired width.

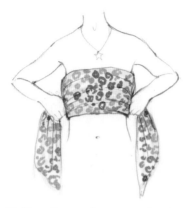

2 Place the scarf over your bust and bring the ends around your back.

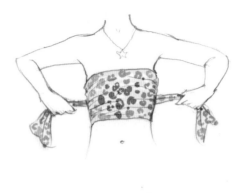

3 Tying once in the back, bring the ends forward.

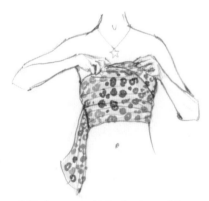

4 Tuck one end into the top of the scarf, ensuring the end is secure.

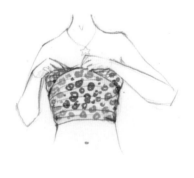

5 Finish by repeating on the other side. Tucking in in this manner will create a sweetheart neckline effect.

✴ THE PRETTY GIRL ✴

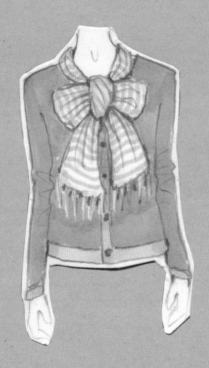

It's hard to imagine a look more enchanting than a bow hung from the neck.
Worn with a cardigan, this style is a cheeky play on an ultra-feminine look.

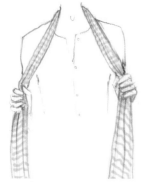

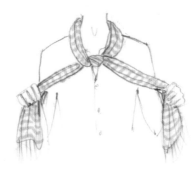

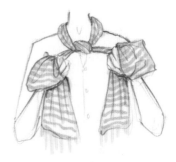

1 Drape a long rectangular scarf around the back of your neck so the ends are even in front.

2 Tie the ends together once, leaving the knot at the level where you'd like the bow to hang.

3 As if you were tying your shoelace, create a "bunny ear" with each side of the scarf and knot together into a bow.

4 Finish by adjusting the ends as you see fit.

- THE MATRON -

Reaching for one of your grammy's scarves won't turn you into
an old maid. Paired with a favorite brooch, this incredibly easy style
imparts an aura of up-to-the-moment womanliness.

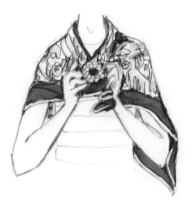

1 Choose a large square silk scarf with nice drape.

2 Drape the scarf over your shoulders, with two corners hanging down your front.

3 Fasten the two front sides of the scarf together below your neck with a brooch to finish.

✳ The LOVE Knot ✳

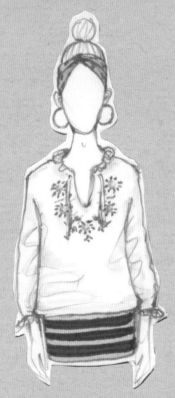

This simple head wrap is as beautiful as two souls joining in eternal love
but is casual enough to wear with your bikini on the beach or with hoop earrings and a simple top.

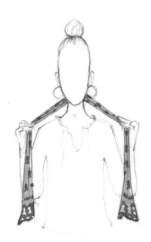

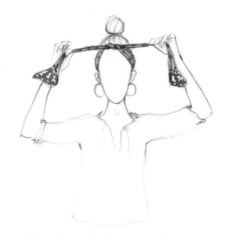

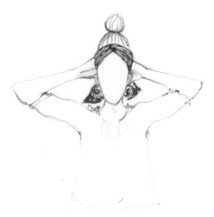

1 Place a long rectangular scarf at the back of your head, below your hairline.

2 Bring the ends forward and tie once at the top of your head.

3 Switch the direction of the ends so that you are bringing them back down to the back of your head. Knot the ends to finish.

∞ THE INFINITY ∞

This look is all about endless style.
With a simple knot and a quick throw over your head,
a universe of possibilities awaits.

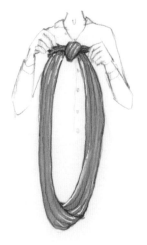

1 Choose a long scarf.

2 Securely knot the ends together.

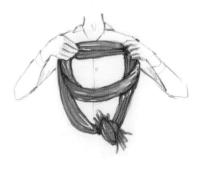

3 Twist the scarf once to create two loops.

4 Finish by bringing both loops over your head and settling around your neck.

= THE KNOTTED BIB =

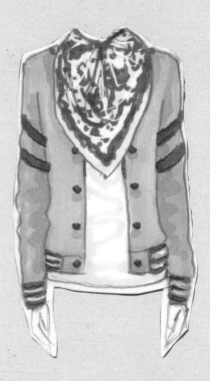

A secret hidden knot creates a gorgeous ruching effect
with this chic update on the Bandit (see page 18).

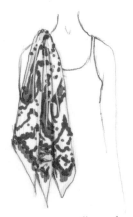

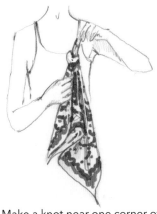

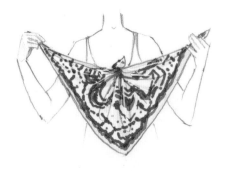

1 Choose a square silk scarf and flip it to the wrong side.

2 Make a knot near one corner of the scarf—you will have formed a triangle by knotting.

3 Flip the scarf back over to the right side. Grab the two ends on the opposite side of the knot.

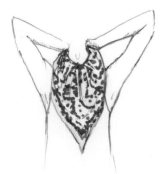

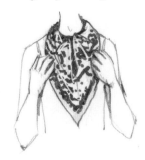

4 With the knot hidden behind the scarf, place the knot at the base of your throat and then securely tie the two corners behind your neck.

5 Finish by adjusting as you see fit.

THE NINJA

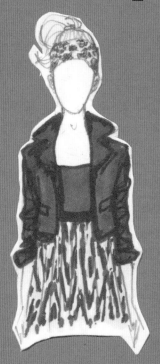

This look doesn't necessarily require an all-black ensemble.
By simply tying a favorite scarf around your forehead,
you'll command style respect wherever you go.

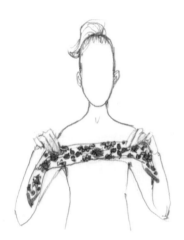

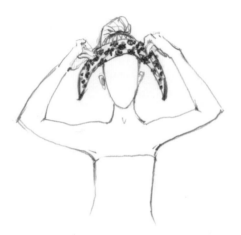

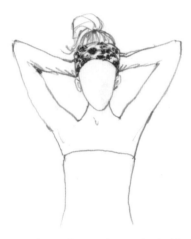

1 Use a small oblong scarf, or fold a small square scarf diagonally into one long length.

2 Place the scarf on your forehead and bring the ends behind your head.

3 Knot the ends together at the back of your head to finish.

— THE SCULLERY MAID —

With a jaunty knot on the side of your forehead, this look channels
both hardworking ladies and our favorite late West Coast rapper.
(Tupac, we know you would approve.) No mop or rhyming skills required.

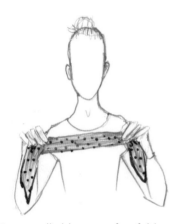

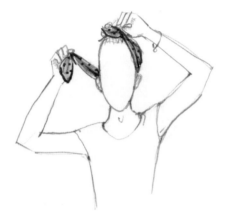

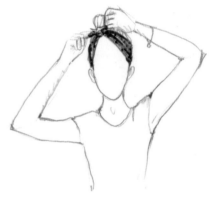

1 Use a small oblong scarf, or fold a small square scarf diagonally into one long length.

2 Place the scarf at the back of your head at your hairline and bring the ends forward.

3 Knot the ends together in the front at a jaunty angle to finish.

The Fan

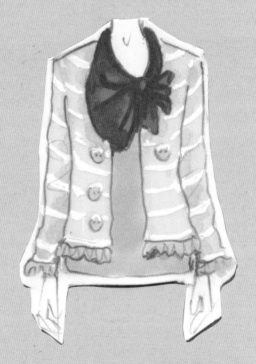

In old Spain, young ladies looking to be courted used their fans to communicate elaborate secret messages to their suitors. Whatever message you'd like to convey, this ornate look will certainly speak to your style.

1 Drape a large oblong scarf around the back of your neck, letting one end hang much shorter than the other down the front.

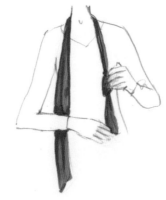

2 Form a loose knot on the shorter end.

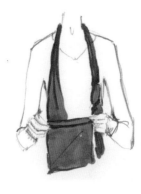

3 Starting from the bottom, accordion-pleat the longer end until it is even with the knot on the opposite end.

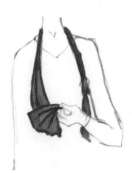

4 On the side closer to the knot, pinch the edge of the pleats with one hand.

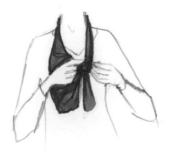

5 Pull the pleated end through the knot.

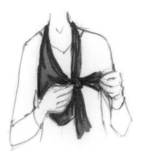

6 Finally, adjust and tighten the knot.

∞ The Cummerbund ∞

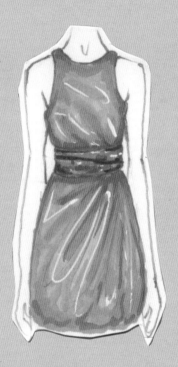

A traditional cummerbund is worn with a tuxedo and bow tie. Channel a
formal gentleman by tying a scarf around your waist; go traditional with a tuxedo shirt
and single-breasted jacket or more feminine by wrapping it around a cocktail dress.

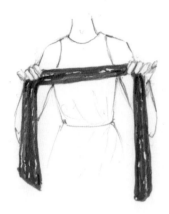

1 Choose a long oblong scarf.

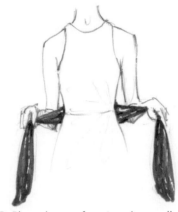

2 Place the scarf against the small of your back.

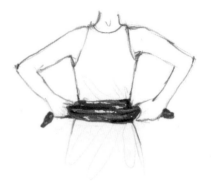

3 Bring the ends forward and cross them across your front.

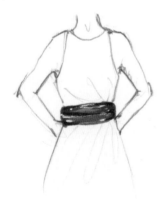

4 Knot in the back to finish.

ᜡ THE AUDREY ᜡ

Take inspiration from one of history's most stylish women. When worn with a sweet shirt and flats, this look channels the gamine with confidence and class.

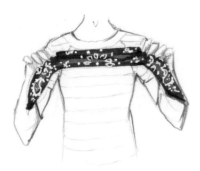

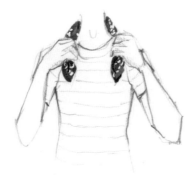

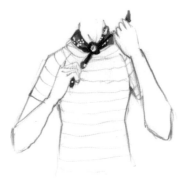

1 Use a small oblong scarf, or fold a square scarf into a long rectangular shape.

2 Place the scarf at the back of your neck, bringing the ends forward.

3 Finish by knotting at the base of your throat.

❖ The Jackie ❖

One of the most fashionable First Ladies frequently donned this classic head cover while gallivanting around Capri. For extra fashion points, take a tip from her effortless look and wear with a black tee, white jeans, and leather sandals.

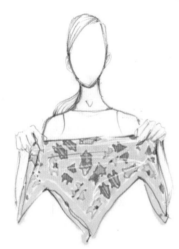

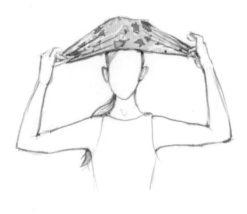

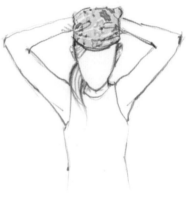

1 Fold a square scarf in half diagonally to form a triangle.

2 Place the long folded edge of the scarf low on your forehead.

3 Bring the folded corners to the back of your head, and finish by tying securely over the loose corners of the scarf.

⊫ the montreal ⊨

When the thermometer dips below freezing, the hardiest French Canadians employ this style (sometimes with two scarves!) when they must go outside. Bundle it underneath your coziest cardigan and warmest parka.

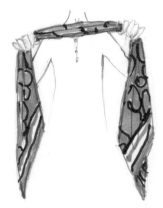 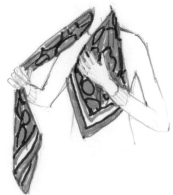 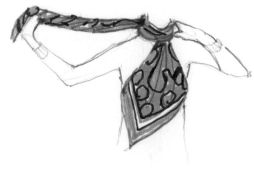

1 Loosely fold a large square scarf into a long rectangular shape.

2 Spread one end of the scarf and secure against your chest, bringing the other side around your neck.

3 Wrap twice around your neck.

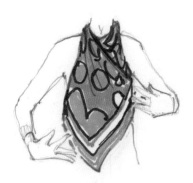 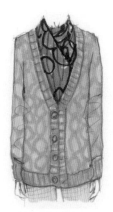

4 Secure the opposite end over the other end, lying flat against your chest.

5 Layer, layer, layer!

THE WEIGHT

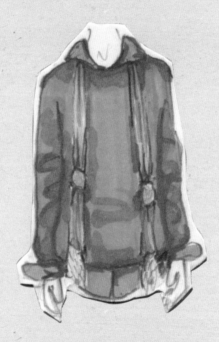

Your favorite scarves aren't always right for every season. Choose this look when you'd like to add some bulk to a lightweight summer scarf for those colder months. A few strategic knots can get any scarf in shape for year-round use.

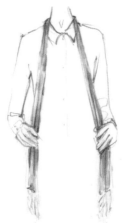 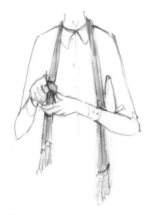 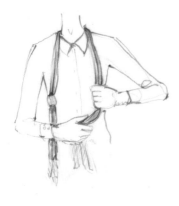

1 Drape a long rectangular scarf around the back of your neck so the ends hang evenly in front.

2 Tie a knot on one side, about halfway between your neck and the ends.

3 Repeat on the other side.

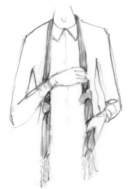

4 Finish by adjusting the knots as you'd like.

~ THE HANDLE ~

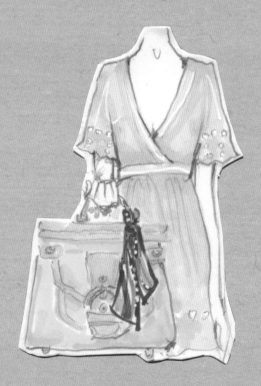

Consider your purse an accessory for your favorite scarf. Even if you carry the same bag every day, swapping out your scarf from time to time keeps your look fresh.

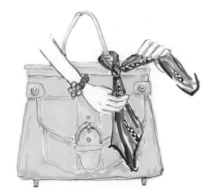

1 Choose a square silk scarf that complements your handbag.

2 Knot the scarf around one handle, and you're done!

- THE CHOKER -

This beguiling look brings the focus to your lovely neck.

 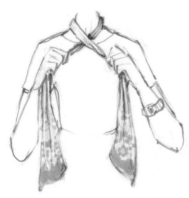 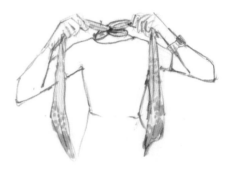

1 Place a long oblong scarf at the back of your neck, leaving both ends even in front.

2 Cross the ends once at the base of your throat.

3 Bring the ends back toward the back of your neck, making sure that you are bringing them back on the same side of the neck that they began on.

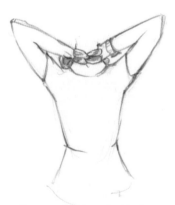

4 Knot or tie a bow behind your neck to finish.

{ the bunny ears }

This trendy twist is cute dressed up or dressed down and
will have you hopping from one party to the next.

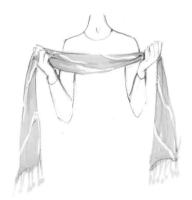

1 Choose a long oblong scarf.

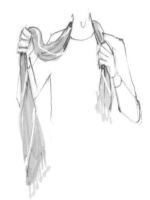

2 Place at the back of your neck, letting one end hang much longer than the other.

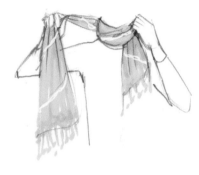

3 Wrap the long end twice around your neck.

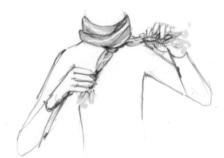

4 Knot the long end with the short end, hiding the knot beneath the loops when you are finished and letting the "ears" hang down.

· The Babushka ·

We've taken a lot of things from the Old Country, including this effortless head cover. It's ideal for protecting your 'do on a rainy day— wear it with a classic trench coat for the full effect.

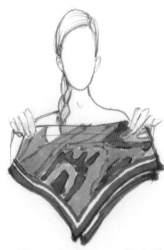

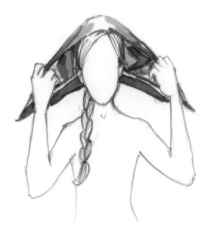

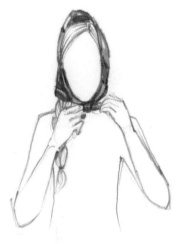

1 Fold a small square scarf in half diagonally to form a triangle.

2 Bring the scarf over your head with the long folded edge of the scarf on your forehead at the hairline and the rest of the scarf draped over your head.

3 Finish by knotting the folded corners securely underneath your chin.

❧ THE PEASANT ❧

Add texture, color, and definition with this look.
Over a high-waisted skirt or A-line dress, this method is proof
that style is not synonymous with social class.

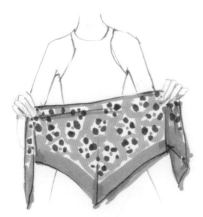

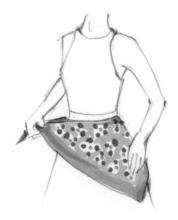

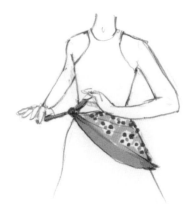

1 Fold a large square scarf in half diagonally to form a triangle.

2 With the loose corners hanging to the side, wrap the scarf around the smallest part of your waist.

3 Finish by knotting the folded corners securely at your side.

The Half Bow

Sometimes an off-center element makes for the perfect balance.
With this free and easy look, you'll strike the right equilibrium.

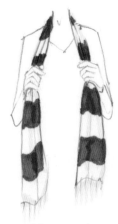

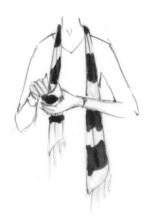

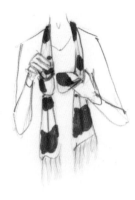

1 Drape an oblong scarf around the back of your neck so that the ends hang evenly in front.

2 Make a loose knot on one side, about halfway between your neck and the end.

3 Pinching the other side of the scarf in the middle, pull it partially through the knot to form half of a bow.

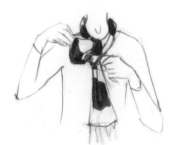

4 Finally, tighten your original knot and adjust the bow as you see fit.

◆ BONUS: THE PUP ◆

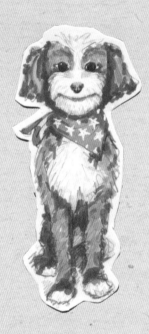

A girl's best friend deserves a scarf just as much as you do. This look is both stylish and useful—your canine will prance the streets with flair *and* be easier to spot on a walk through the woods!

1 Fold a small square scarf (that you don't mind getting dirty!) diagonally to form a triangle.

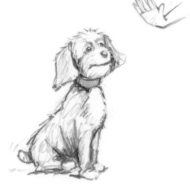

2 Tell your pooch to "sit."

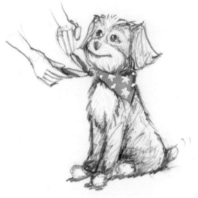

3 Finish by knotting the scarf loosely over your dog's collar.

HISTORY OF THE SCARF

Obviously, scarves were around way before I started dreaming up ways to illustrate them for this book (though at times, that effort did feel quite historical!). There are practically as many ways to tie a scarf as there are manners in which this versatile accessory has gotten tangled up throughout history.

In ancient Egypt, QUEEN NEFERTITI–perhaps the earliest style heroine–sported a scarflike head wrap under her iconic headdress, which was later immortalized in her famous bust.

Meanwhile, in ancient China, military rank was signified by a soldier's hairstyle and dress, including his scarf. Sentry men tied pieces of cloth around their necks in a style similar to the Boy Scout (page 46).

In ancient Rome, men tied linen kerchiefs called *sudariums* (a.k.a. sweat rags) around their necks or belts to wipe away perspiration beneath the hot sun. Apparently Roman women could sweat, too, because they soon adopted the method.

Scarves became articles of chivalry in the Middle Ages of Europe when knights carried the tokens from their ladies into battle. (Can you say romantic?)

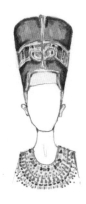

QUEEN NEFERTITI

JOSEPHINE

In the seventeenth century, Croatian mercenaries echoed the Chinese tradition of scarves as a marker of rank with soldiers wearing white cotton scarves and officers sporting silk.

Later, during the French Revolution, men and women wore different colored scarves to show their political leanings—*Liberté, Egalié, Fraternité, et Cravates, mais oui!* And while I consider the French to be the epitome of effortless yet elegant scarf style, the French word for scarf, *cravat*, is actually derived from the Croatian word for scarf, *kravata*.

Despite the fact that India had been weaving Kashmir shawls—made of pashmina or cashmere wool, often designed with bright paisley patterns—for centuries, it wasn't until Napoleon brought some

back to his first wife, JOSEPHINE, that the shawl fully implanted itself into fashion history.

The military thread of the scarf's history remained strong entering the twentieth century when, during World War I and World War II, knitting scarves and other necessities for soldiers was deemed patriotic in America. Also during these wars, aviator pilots wore scarves to keep warm in high altitudes and to pad the neck.

However, my award for best-in-flight use of the scarf goes to pioneering pilot AMELIA EARHART, who also had a keen eye for style (she even designed her own clothing line!). Ms. Earhart embodied high-flying panache with her shearling aviator jacket, leather cap, goggles, and flowing silk scarf.

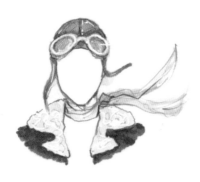

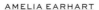

AMELIA EARHART

FLAPPER

Through the twentieth century, the scarf has been tied to fashion and folly alike. Beloved dancer Isadora Duncan was famously killed by her long red scarf when it got caught in the wheel of her convertible. (Keep your Top Down [page 44] tied tight, my dearies!)

The FLAPPERS of the 1920s, known for waistless dresses, cropped hair, and loose morals, tied scarves over their bobs to keep hair polished while dancing the Charleston in the roaring speakeasies of the day.

Toward the end of the decade, in 1928, centuries-old leather goods maker Hermès began to create silk scarves, modeling them after scarves Napoleon's soldiers wore in battle. In countless patterns, designed by innumerable artists and designers, the Hermès scarf has been worn by some of the biggest fashion icons in history, from Audrey Hepburn to Hillary Clinton. My favorite iteration of the Hermès scarf look was when Grace Kelly fashioned one as a sling after she broke her arm in 1956. Trés chic!

Originality is the name of the game when it comes to scarves. Naturally, Jackie O was known for her elegant use of the scarf. But I believe her cousin, Edith Bouvier Beale, better known as Little Edie, was positively smashing with her head scarves. Secured with a brooch and worn with turtlenecks and furs, her scarves are immortalized in the film *Grey Gardens*.

STEVIE NICKS + STEVEN TYLER

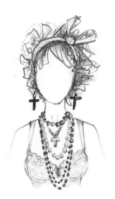

MADONNA

Points for originality also go to **STEVIE NICKS** of Fleetwood Mac and **STEVEN TYLER** of Aerosmith, who proved that a rock star is nothing without a scarf— or twelve—swaying under the mic.

On the silver screen, notable scarf mentions go to Faye Dunaway in the 1967 film *Bonnie and Clyde* (the *ultimate* Bandit [page 18] inspiration) and Diane Keaton in 1977's *Annie Hall*, who made Woody Allen fall in love with her borrowed-from-the-boys suits, hats, and drape-y scarves.

In the '80s, pop princess **MADONNA** corralled her epic perm with a subversive version of the Scullery Maid (page 92) during her infamous "Like a Virgin" days.

Harkening back to an earlier time, the cashmere pashmina, as prevalent in the 1990s as the nylon Prada backpack, was dubbed a "cashmiracle" by Carrie Bradshaw, played by Sarah Jessica Parker, in a 1999 episode of *Sex and the City*.

Even now as we enter the second decade of the twenty-first century, the scarf shows no evidence of fading away. The late, great author and screenwriter Nora Ephron extolled their concealing virtues in her 2006 book *I Feel Bad About My Neck*, while Alexander McQueen's much-copied silk skull scarves whipped up a frenzy of a trend, still appearing on celebrities and fans alike.

CROSS-REFERENCE INDEX

ACKNOWLEDGMENTS

Thank you to Laura Lee and Allison at Chronicle Books—their patience and encouragement brought this book to life in ways I couldn't have imagined. To Greer, for her incredible modeling skills (and her constant supply of cookie dough). To Jonas and Cullen, for giving me the means to turn my ideas into reality. To Torie, for being an eye or ear to rely on and a studio-mate to look up to. To Laura, Ashlea, Jana, Jordan, Safia, and Katie, because our friendships are the spark I couldn't live without. To my brother, Alex, who had to live with me while I made this book, and whose coaching and tough love kept my gas tank full the whole way through. To my parents, Larry and Mary, for their unending support and utter

lack of pretentiousness when it comes to "things that are a big deal"—you keep my feet on the ground where they belong. To Zoe, the best damn dog to ever sport a scarf. Last but not least, to my grandmother Enid, who always seems to cosmically come through. While visiting her just days before finishing the final outline of this book, I unearthed a treasure trove of old scarves and vintage "How to Tie a Scarf" pamphlets full of styles I had never seen before. These last-minute finds inspired some of my favorite looks in this book: the Knotted Bib, the Fan, and the XX. In the same way a scarf adds that final flourish, I credit my grandmother's creative spirit for the finishing touches on this book.